D0394481

This book belongs to

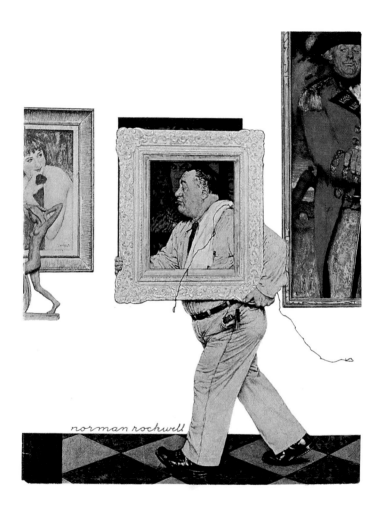

norman rockwell

THE

Wit & Humor

OF

NORMAN ROCKWELL

———

ARIEL BOOKS

ANDREWS AND McMEEL

KANSAS CITY

Frontispiece: FRAMED
Saturday Evening Post cover,
March 2, 1946

Book design by Susan Hood

THE

Wit & Humor

OF

NORMAN ROCKWELL

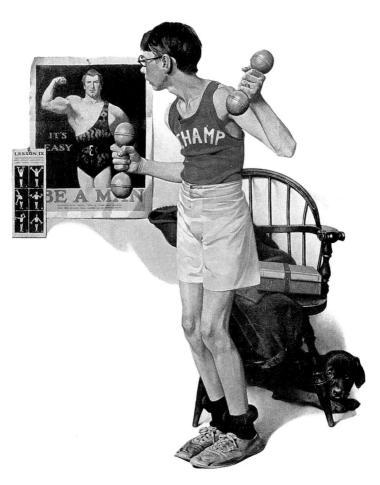

THE BODY BUILDER

—

Saturday Evening Post cover
April 29, 1922

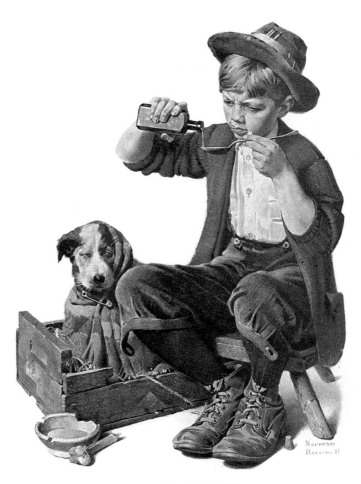

BEDSIDE MANNER

Saturday Evening Post cover
March 10, 1923

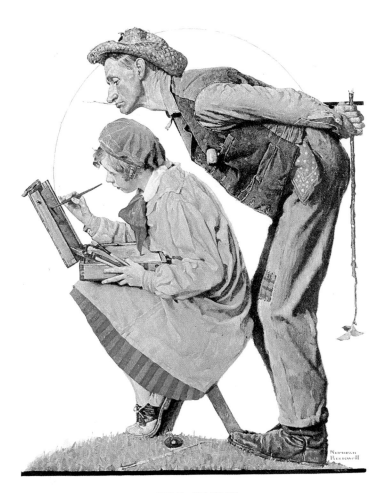

THE CRITIC

—

Saturday Evening Post cover
July 21, 1928

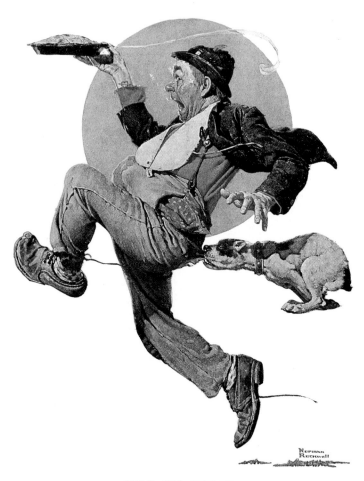

THE PIE THIEF

—

Saturday Evening Post cover
August 18, 1928

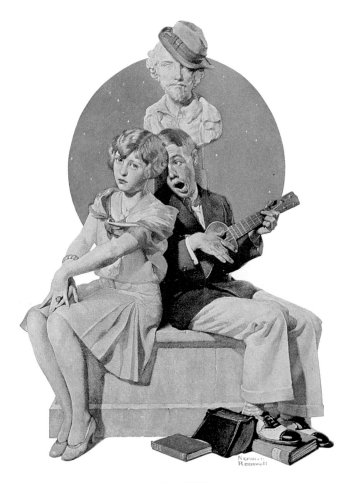

SERENADE

Saturday Evening Post cover
September 22, 1928

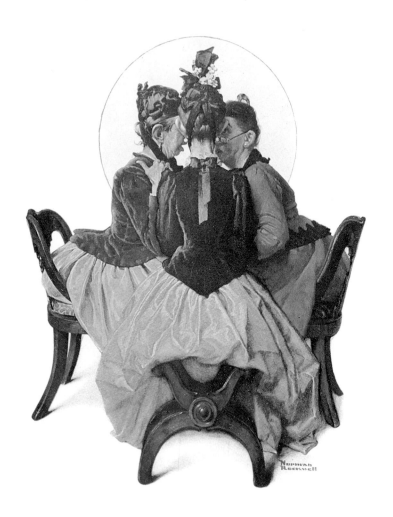

THE GOSSIPS

—

Saturday Evening Post cover
January 12, 1929

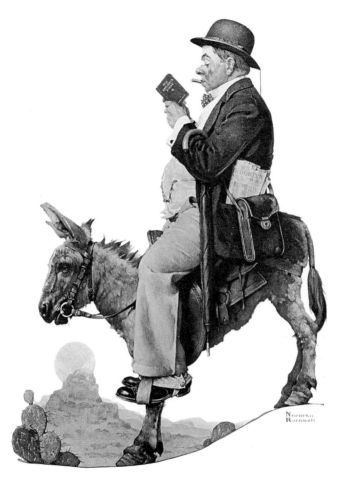

TRAVELER

———

Saturday Evening Post cover
July 13, 1929

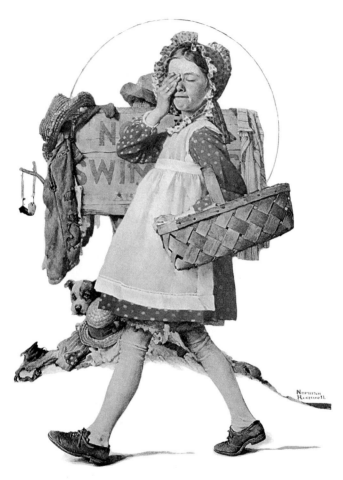

NO SWIMMING

—

Saturday Evening Post cover
June 15, 1929

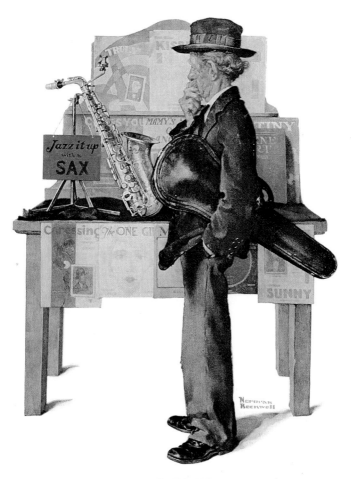

JAZZ IT UP

———

Saturday Evening Post cover
November 2, 1929

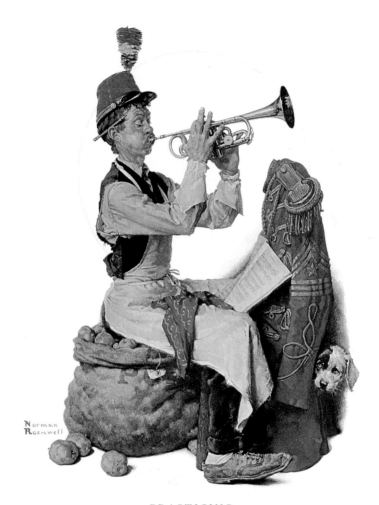

PRACTICING

Saturday Evening Post cover
November 7, 1931

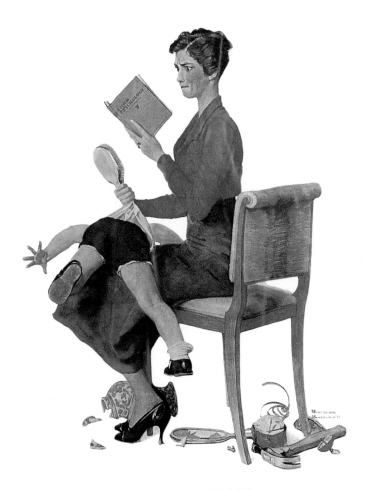

CHILD PSYCHOLOGY

Saturday Evening Post cover
November 25, 1933

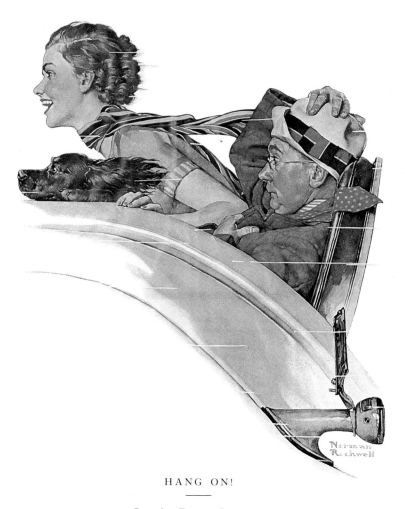

HANG ON!

Saturday Evening Post cover
July 13, 1935

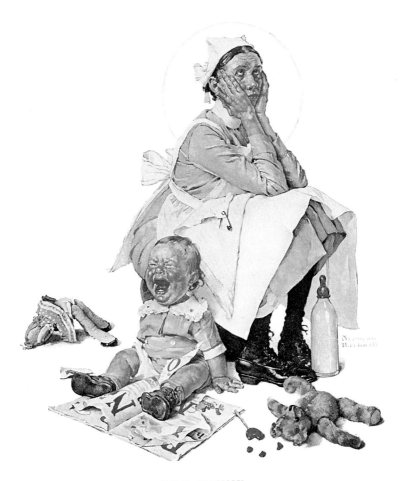

THE NANNY

Saturday Evening Post cover
October 24, 1936

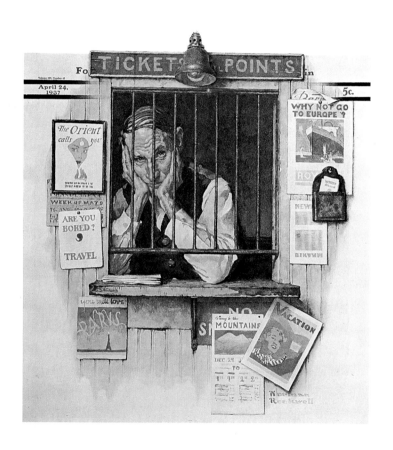

SEE THE WORLD

Saturday Evening Post cover
April 24, 1937

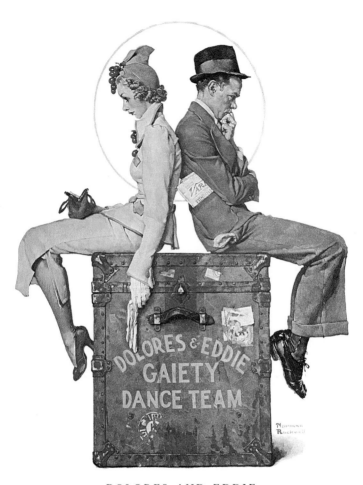

DOLORES AND EDDIE

―

Saturday Evening Post cover
June 12, 1937

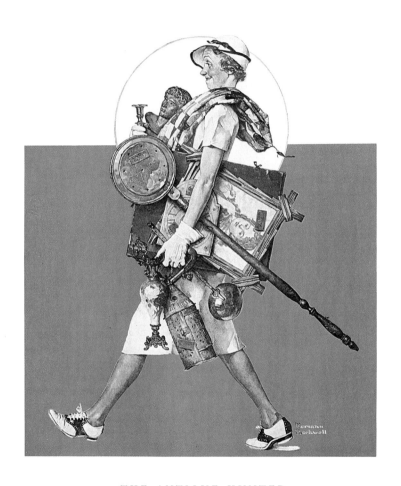

THE ANTIQUE HUNTER

Saturday Evening Post cover
July 31, 1937

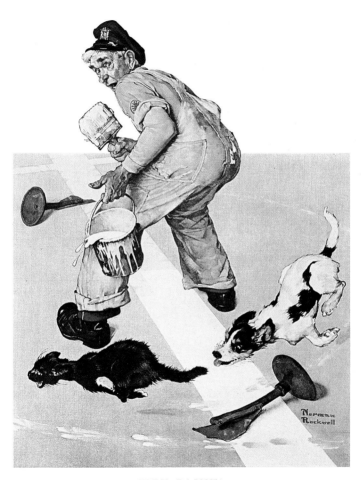

WET PAINT!

Saturday Evening Post cover
October 2, 1937

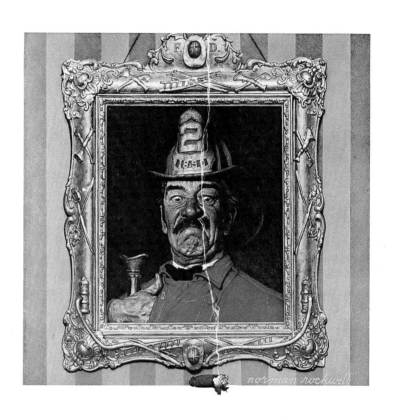

FIRE!

Saturday Evening Post cover
May 27, 1944

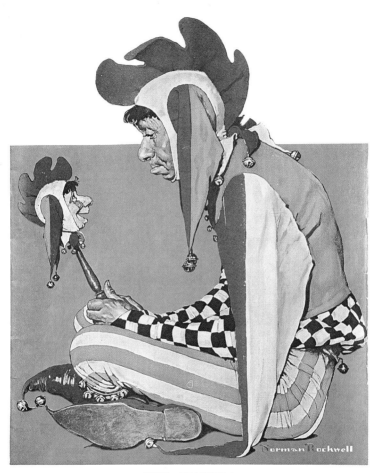

THE JESTERS

Saturday Evening Post cover
February 11, 1939

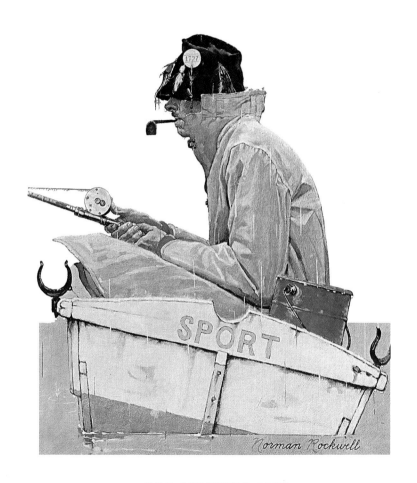

THE SPORTING LIFE

Saturday Evening Post cover
April 29, 1939

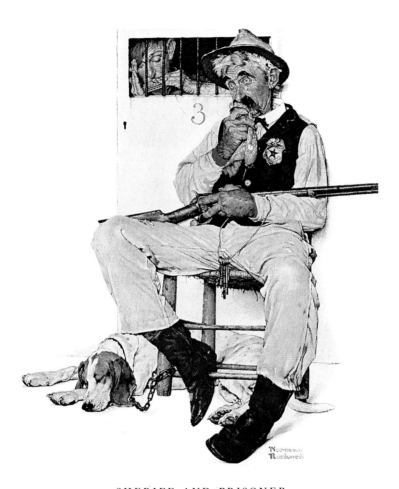

SHERIFF AND PRISONER

———

Saturday Evening Post cover
November 4, 1939

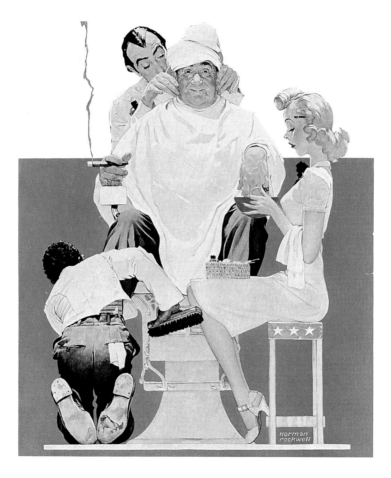

THE WORKS!

Saturday Evening Post cover
May 18, 1940

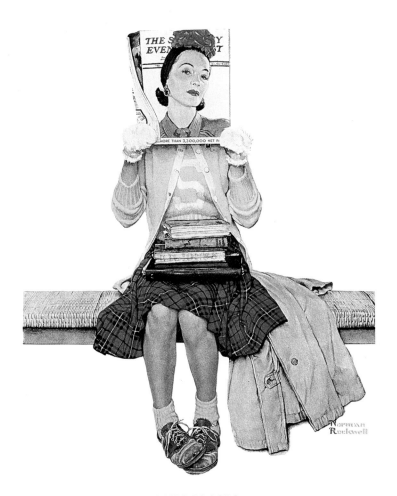

SCHOOLGIRL

—

Saturday Evening Post cover
March 1, 1941

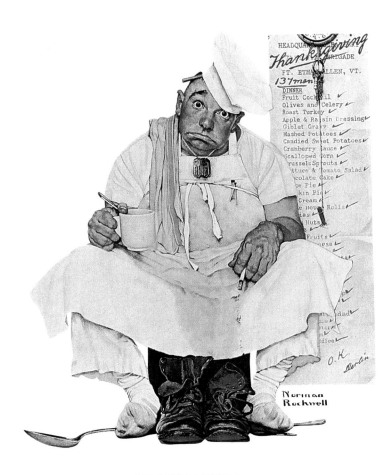

THANKSGIVING DAY

———

Saturday Evening Post cover
November 28, 1942

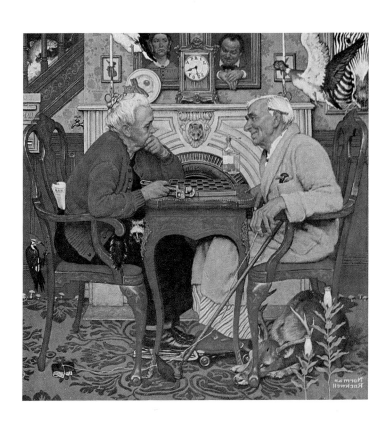

PLAYING CHECKERS

Saturday Evening Post cover
April 3, 1943

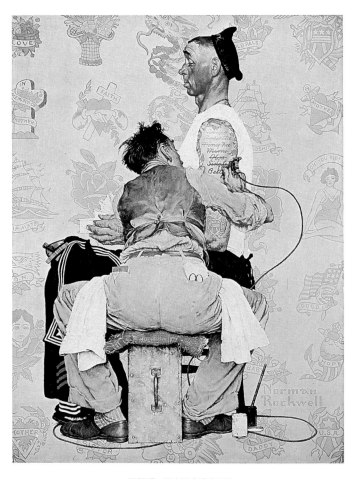

THE TATOOIST

—

Saturday Evening Post cover
March 4, 1944

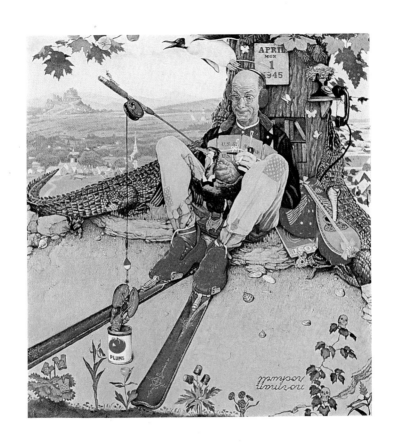

APRIL FOOL'S

—

Saturday Evening Post cover
March 31, 1945

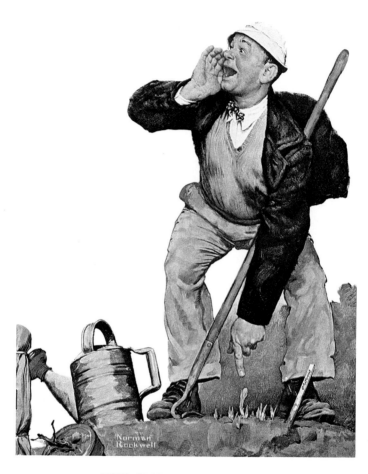

THE HAPPY GARDENER

—

Saturday Evening Post cover
March 22, 1947

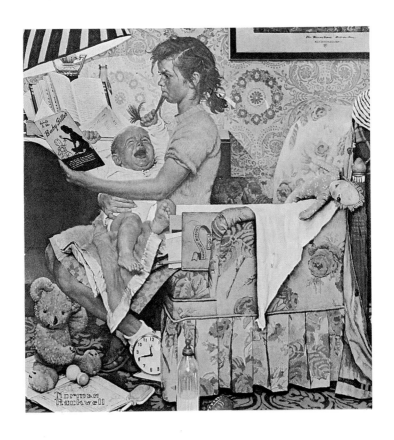

BABYSITTING

———

Saturday Evening Post cover
November 8, 1947

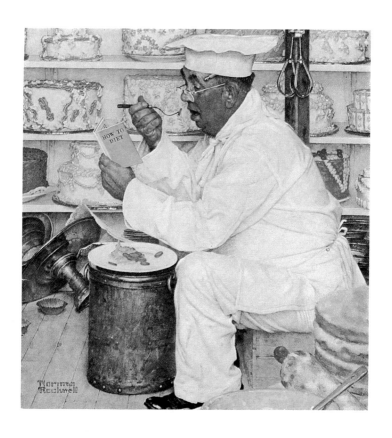

THE DIETER

———

Saturday Evening Post cover
January 3, 1953

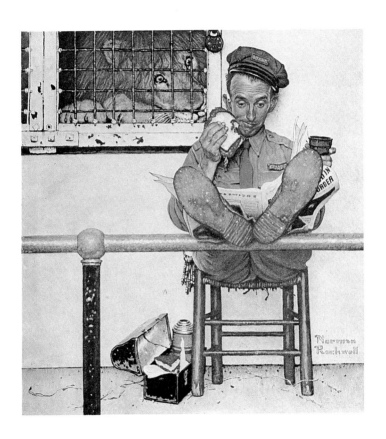

FEEDING TIME

Saturday Evening Post cover
January 9, 1954

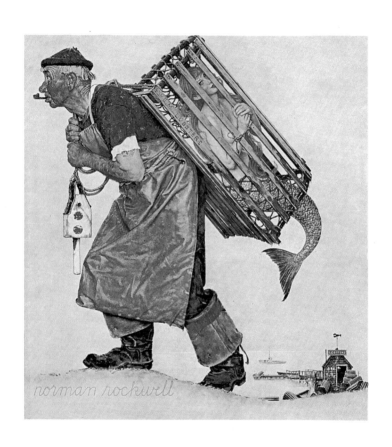

A FAIR CATCH

Saturday Evening Post cover
August 20, 1955

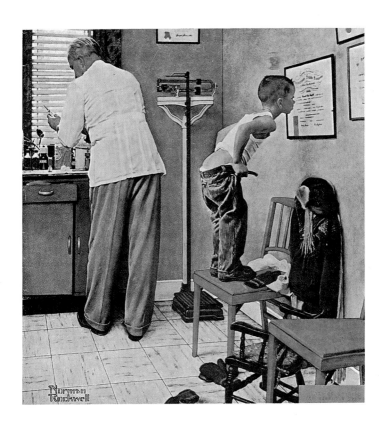

AT THE DOCTOR'S

Saturday Evening Post cover
March 15, 1958